GO FORTH!

GO FORTH!

CHRONICLE BOOKS
SAN FRANCISCO

Library of Congress Cataloging-in-Publication Data available.

ISBN 978-1-4521-5510-4
Manufactured in China

Design and front cover art by Rachel Harrell

Back cover art, clockwise:
Yee Haw: Allison Black
Walk & Think: nastia sleptsova
Stay Humble Hustle Hard: Jennet Liaw
Start Today: Stephanie Certa
You Are Awesome: Monica Ramos

10 9 8 7 6 5 4 3 2 1

Chronicle Books LLC
680 Second Street
San Francisco, California 94107

www.chroniclebooks.com

OK, HERE'S THE THING. WE'RE ALL SCARED.

The people who seem the bravest, the strongest, the most audacious, are often the ones who are the most scared of all. They just don't let it stop them. When faced with the choice between doing the important or exciting or adventuresome thing, that also just so happens to be the hard or frightening or daunting thing, or *not* doing that important/hard, exciting/frightening, adventuresome/ daunting thing, these people bear in mind that old adage about the real nature of courage—that courage is not never feeling fear, it's feeling the fear and doing it anyway.

And here's the thing. You are already one of those people. They are not some special breed of mountain-climbers and

speech-givers and globe-trotters. No. They are all of us. They are you. We have all had the experience of standing on the brink of something new and doubting whether or not we could tackle it, and then moving forward and tackling the heck out of it. Did we sometimes fail? Yep. Did that matter? Not in the least.

The artists who made the work in this book—all of it encompassing messages of hope and courage and positivity—know that life is not a tally sheet chalking up successes against failures and looking for a win. No. Life, each of these artists reminds us in their own way, is about what you endeavored, what you essayed, what you dared, and what you tried. Win or lose makes no difference—what's important is that you played.

Maybe that means loving, maybe that means going, maybe that just means doing the dishes. Whatever going forth means to you, get ready to be given the most daring gift of all: the gift of permission. Permission to move forward, permission to take delight, permission to be afraid, permission to fail. You already hold the potential inside of you; the art in this book is just telling you to let it out.

Whatever little nudge you need to tip over that brink and into your next great adventure, here it is. Go forth.

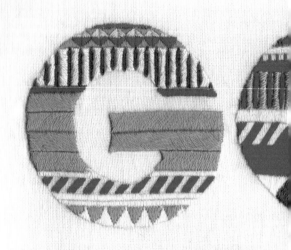

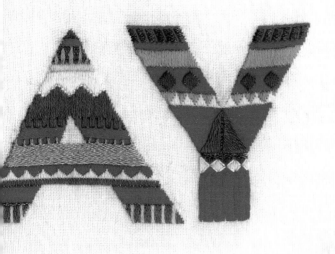

you got this

GET HAPPY

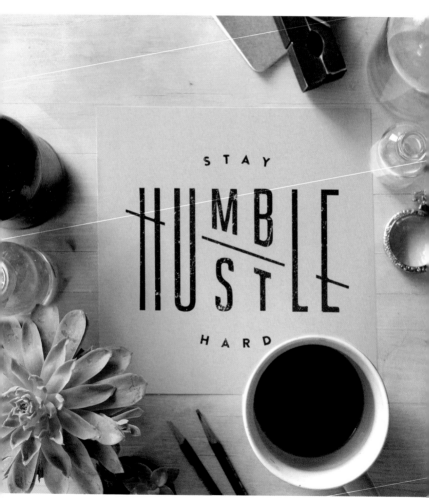

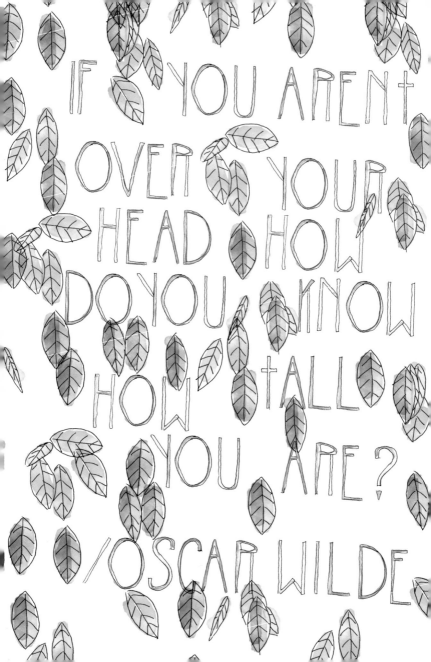

IF YOU ARENT OVER YOUR HEAD HOW DO YOU KNOW HOW TALL YOU ARE?

/OSCAR WILDE

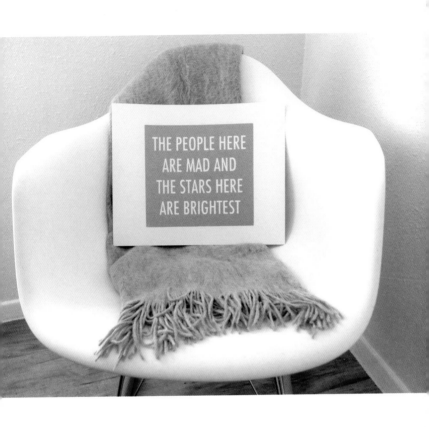

THE PEOPLE HERE
ARE MAD AND
THE STARS HERE
ARE BRIGHTEST

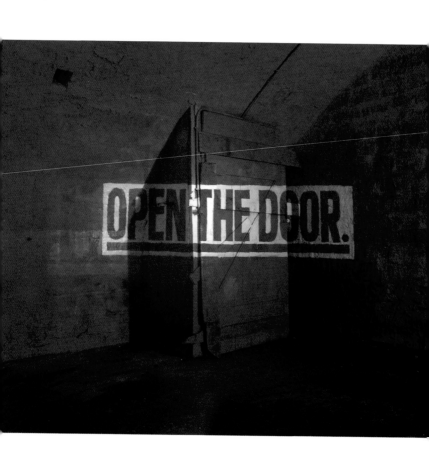

You are prettier than any diamond

some

FANT
ASTIC

place

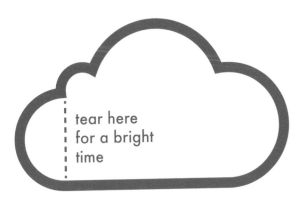

tear here
for a bright
time

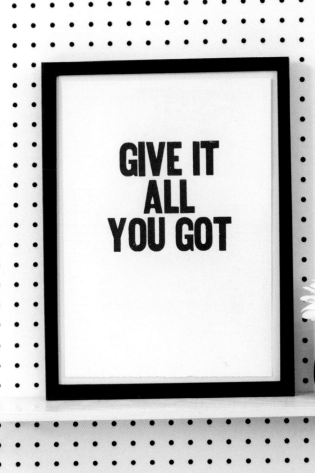

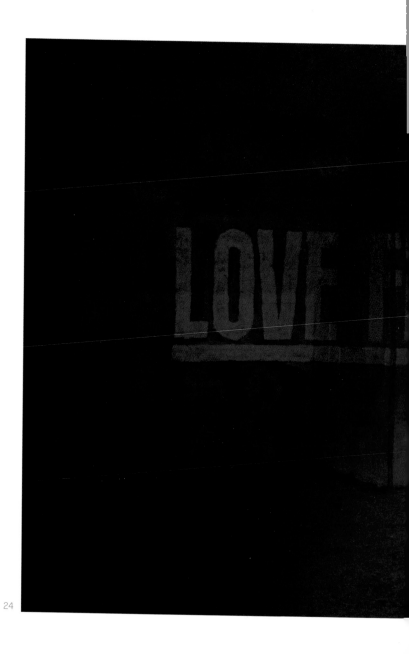

BE THE LOVE YOU NEED THAT'S ALL

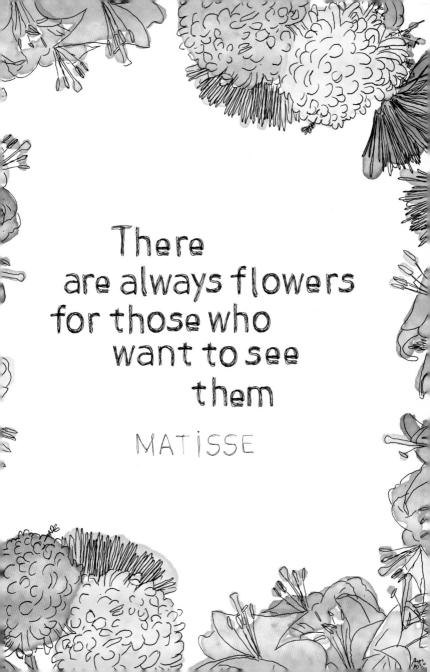

YEE
HAW*

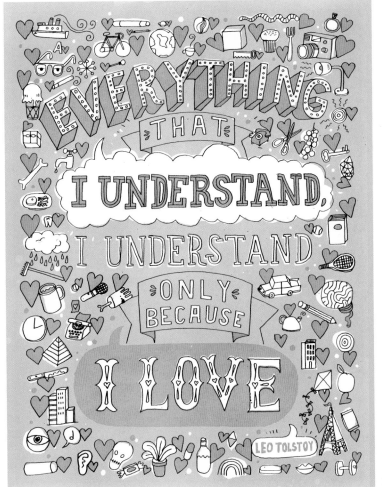

EVERYTHING THAT I UNDERSTAND, I UNDERSTAND ONLY BECAUSE I LOVE

LEO TOLSTOY

31

WALK & THINK

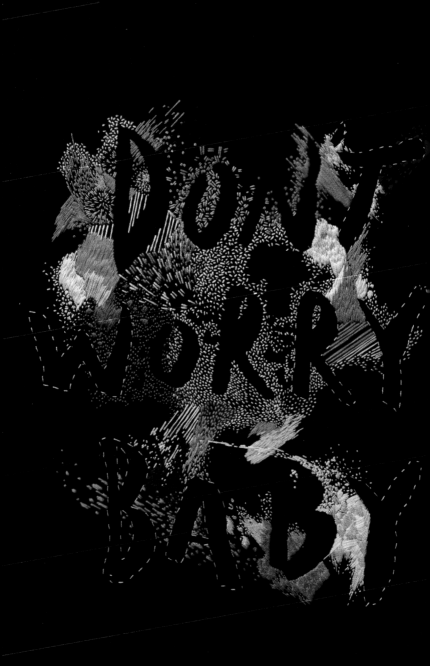

BE NOT AFRAID JUST BE YOU

WHY YES, YES YOU CAN!

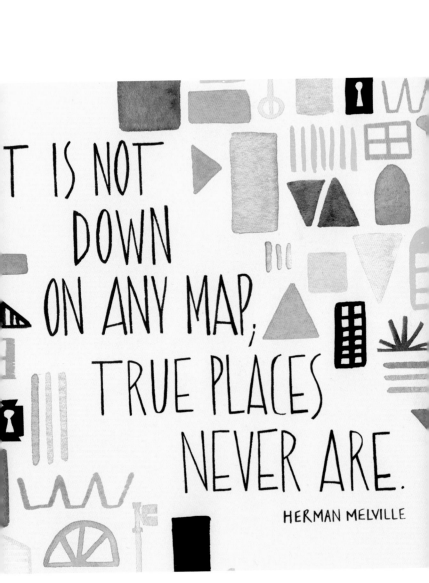

T IS NOT DOWN ON ANY MAP; TRUE PLACES NEVER ARE.

HERMAN MELVILLE

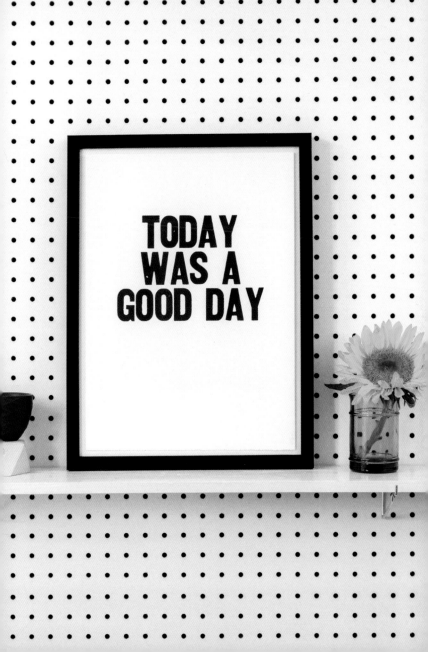

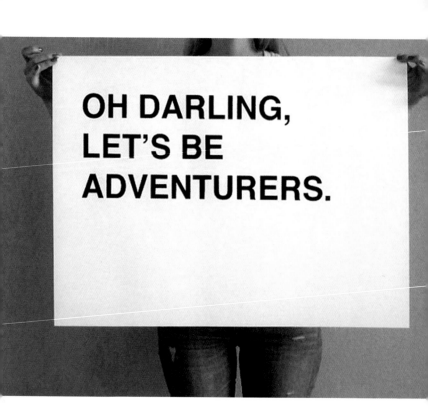

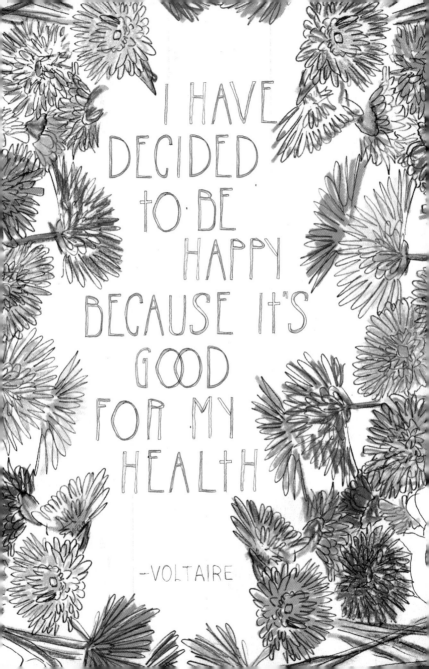

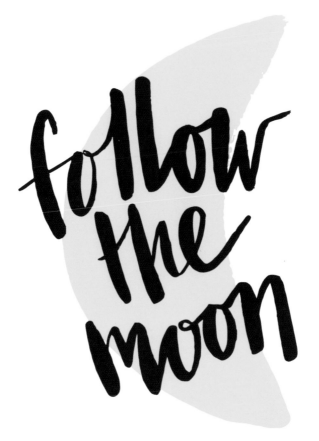

follow the moon

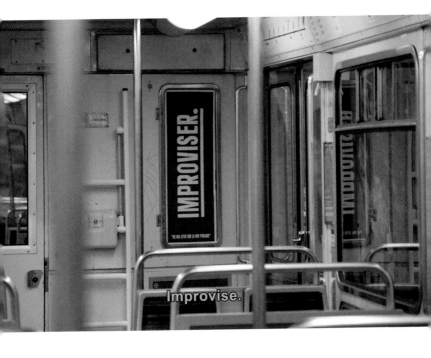

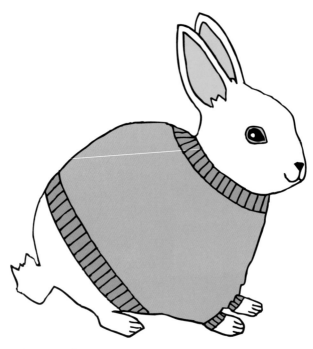

I'VE BEEN A good bunny.

TAKE NO PRIS -O- NERS

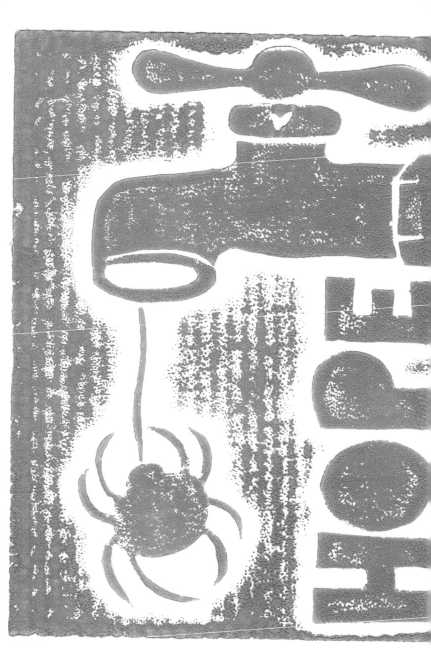

be true to who you are

K.BURESKI

HiP HiP
HOO
RAY!

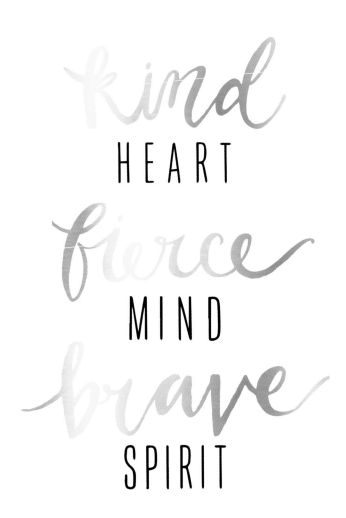

kind HEART

fierce MIND

brave SPIRIT

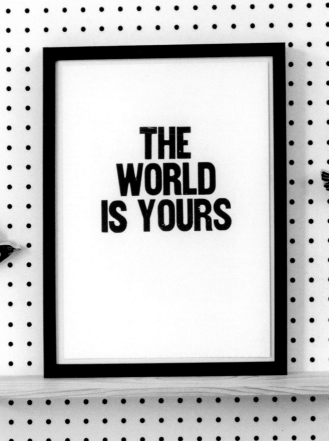

THE
WORLD
IS YOURS

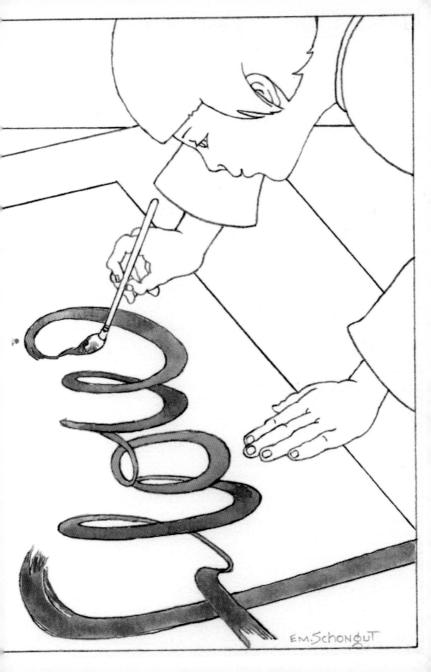

THE WORLD IS YOUR *oyster*

IF YOUR

ship

DOESN'T COME IN

~~~

*swim*

*out*

TO MEET IT

# DO IT WITH
# GUSTO

UNWAVERING
UNCOMMON
COMMITMENT

# YOU ARE MY FAVORITE

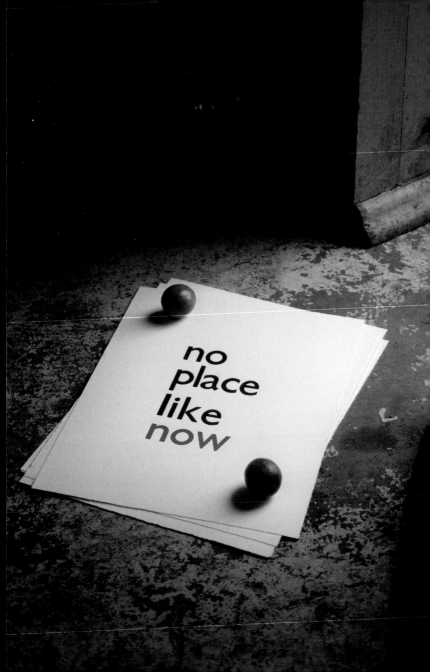

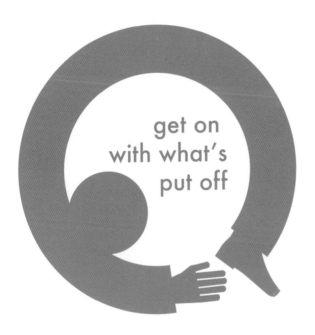

get on
with what's
put off

# STOP WORRYING

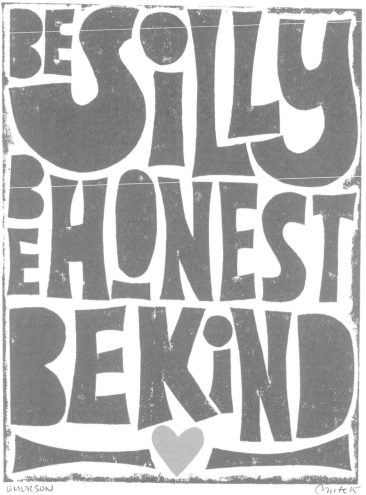

BE SILLY
BE HONEST
BE KIND

EMERSON

Curtis

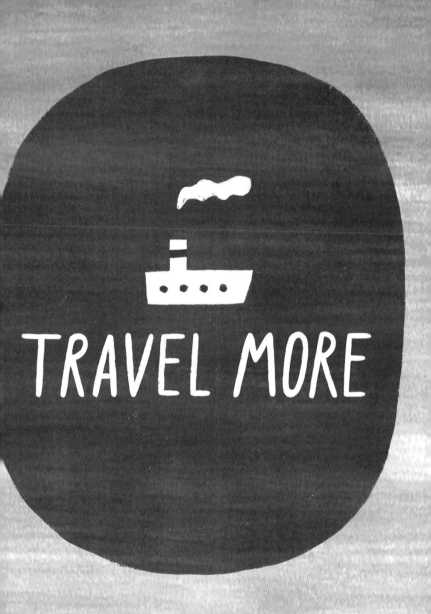
TRAVEL MORE

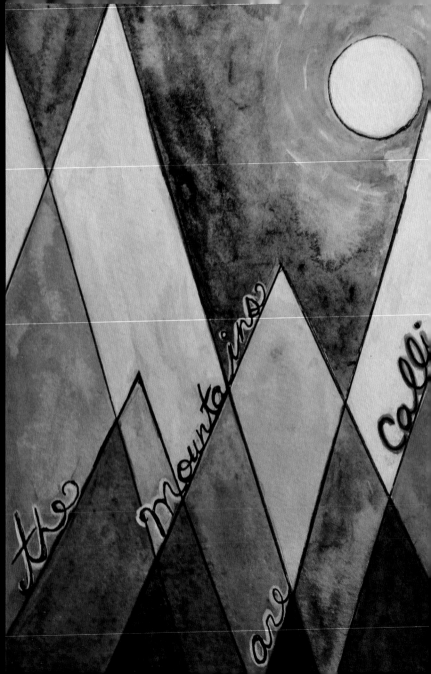

you look wonder- ful.

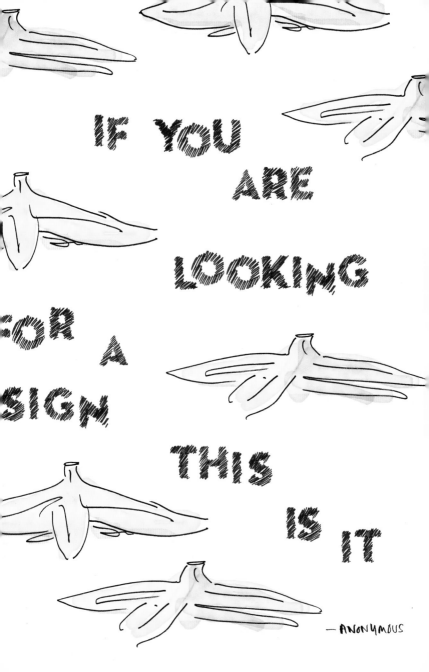

start
today

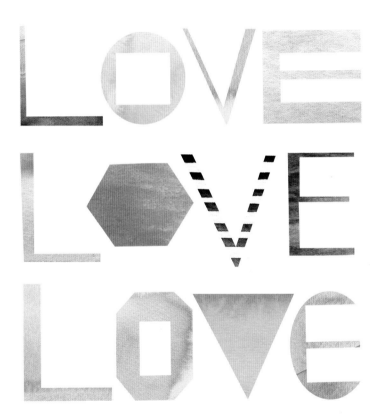

ACCEPT

ACCEPT

ACCEPT

ACCEPT

ACCEPT

ACCEPT
THE GOOD

BE KIND
be Curious
BE SMART
Be BRAVE
be yourself

K.BARUSKI

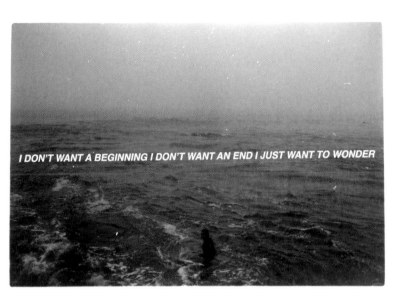

# BE FREE

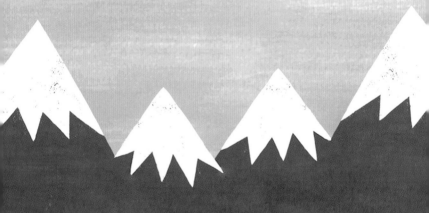

# GROW YOUR

# OWN

# SMILE

Things are about to get really good.

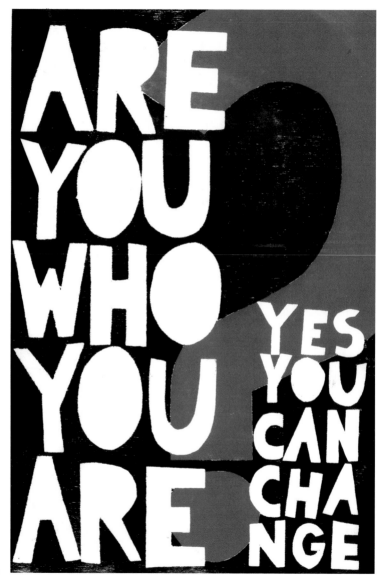

# IMAGINE THE POSSIBILITIES

**WANT**          **NEED**

# TRYING IS TIRING
# BUT IT IS THE ONLY
# WAY TO SUCCEED

It is advisable to look
from the
tide pool
to the
STARS
and back to the
tide
pool
again.

In every
cloud
there is a
silver
lining.

I BELIEVE IN
GOOD PEOPLE

You are a
modern wonder.

# FIND YOUR PLACE

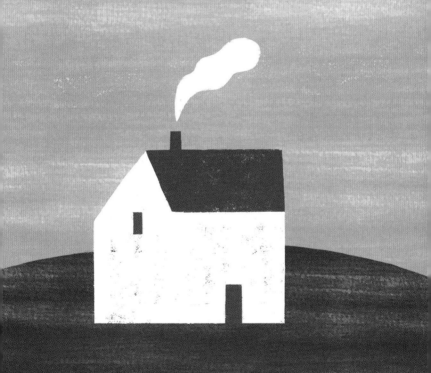

# ART CREDITS